AMERICAN UTOPIA

AMERICAN UTOPIA

words

DAViD
BYRNE

aRt

MAiRa
KALMAN

BLOOMSBURY PUBLISHING
NEW YORK · LONDON · OXFORD · NEW DELHI · SYDNEY

Despite all that has happened,

despite all that is still happening,

I think there is still possibility—

we are still a work in progress.

We're not fixed,

our brains can change.

Who we are thankfully extends

beyond ourselves...to the

connections between all of us.

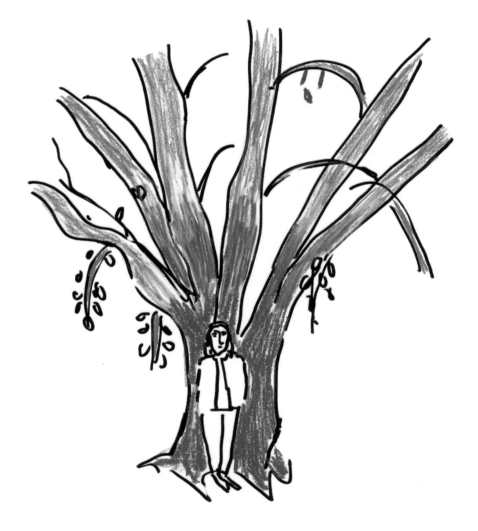

everything changes

everything stops

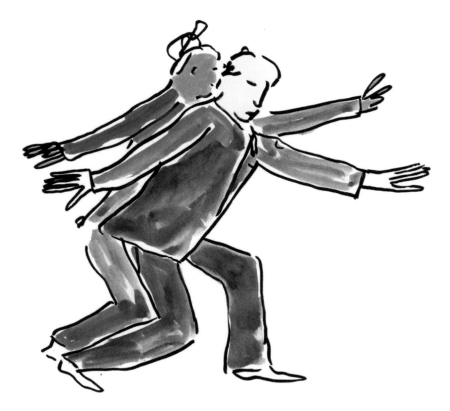

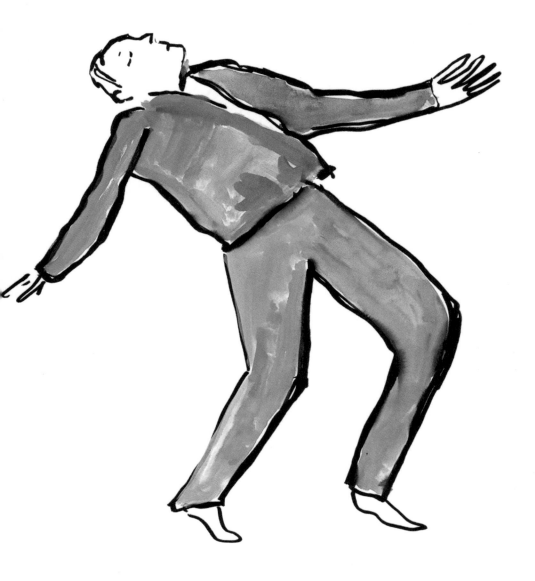

every day is a miracle

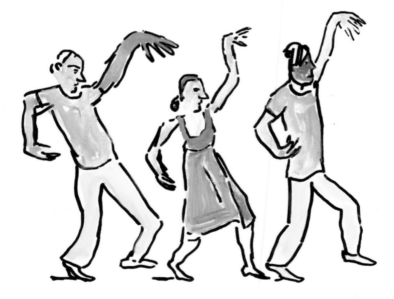

Good Intent, KS

wandering the city
looking for a home

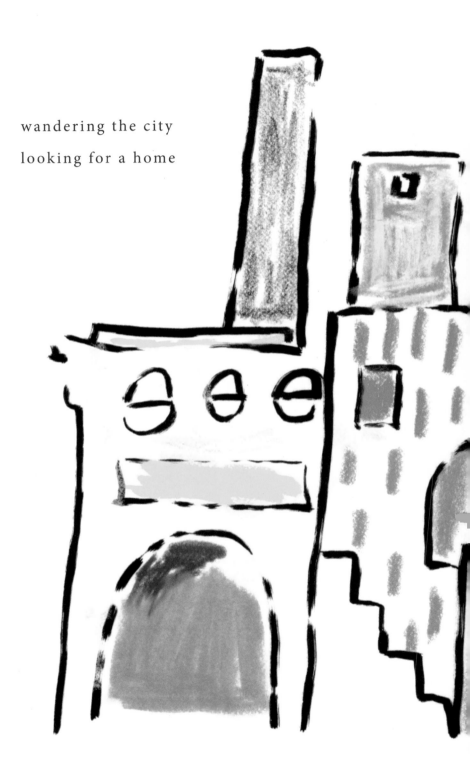

one can only guess

would you like to talk about it?

ZIG

ZAG,

OR.

this is

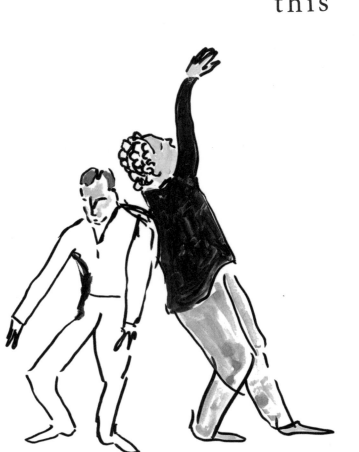

the best I can do

I staple my heart to your love dear

your kisses

he inhaled

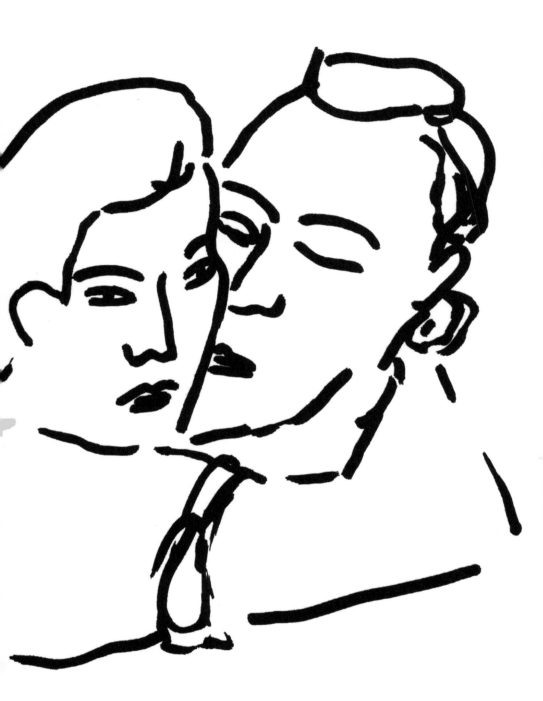

home,
WA.

HEY

it's not dark up here

HEY

it's not very far

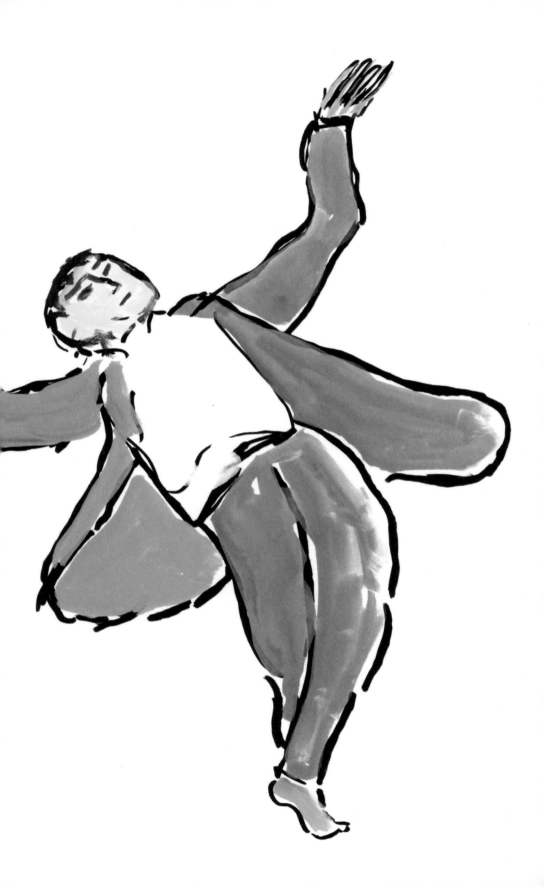

FROGVILLE,
OK.

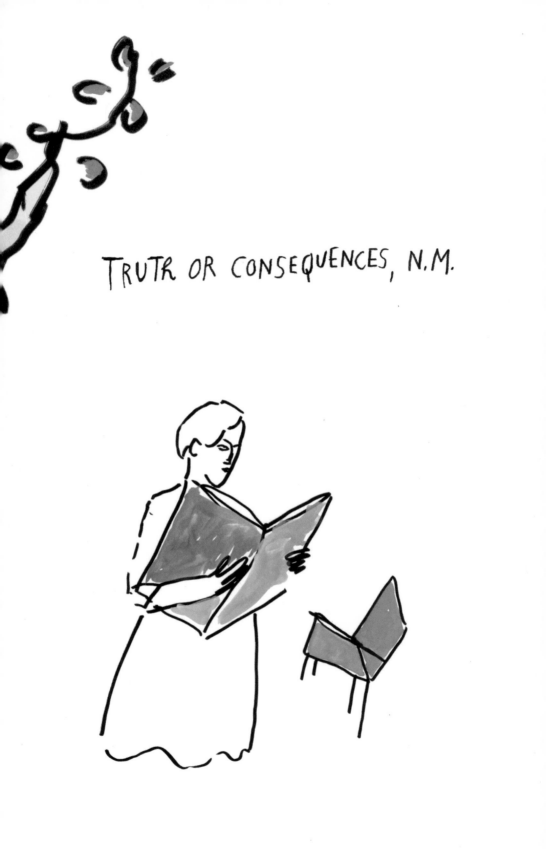

TRUTH OR CONSEQUENCES, N.M.

my life is in your hands now

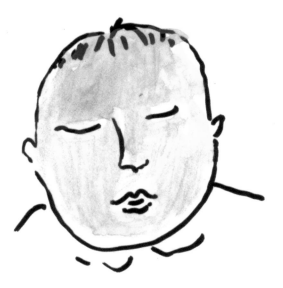

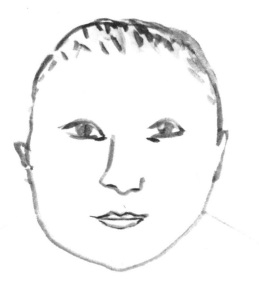

and that's what we're doing it for

but beauty is not what we're after

What are those people

doing over there?

Should I be doing that TOO?

Are they like ME?

Are they LOOKING at me?

Should I go over and TALK to them?

Is there a LOGIC to this?

Is it supposed to make SENSE?

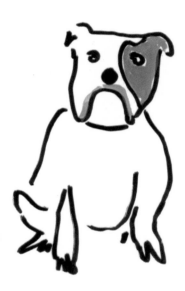

the dog

shows no

concern

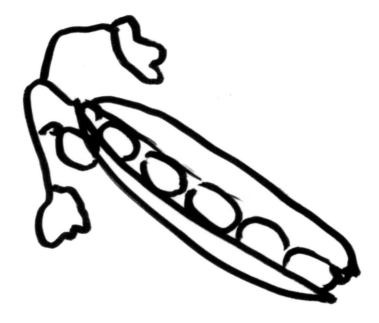

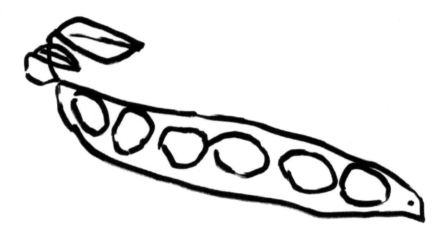

PAW PAW, MI

make a

closer inspection

I'm not alone

and we're all the same
and the world won't end
it will just change its name

CREAM
CAN
JUNCTION,
ID.

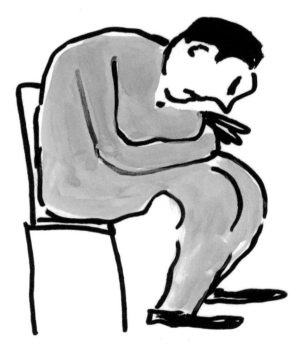

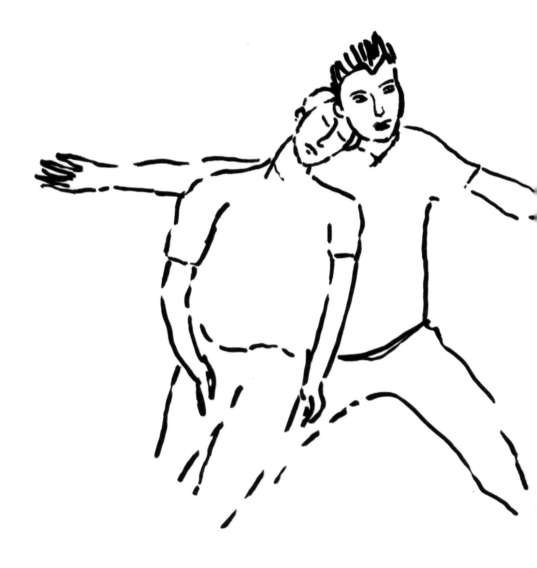

what am I supposed to know about *this?*

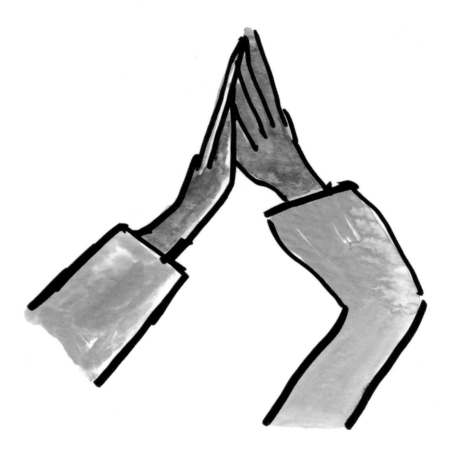

what am I supposed
to have in my hands?

LINCOLN, NE

TOAD HOP, IN.

LUBBOCK, TX.

Fümms bö wö tää zää Uu,

Uu zee tee wee bee fümms.

rakete rinnzekete

rakete rinnzekete

rakete rinnzekete

rakete rinnzekete

rakete rinnzekete

rakete rinnzekete

Beeeee

bö

excerpt from *Ursonate*
Kurt Schwitters, 1932

the poet Hugo Ball said
the Dadaists' aims were
"to remind the world that there are
people of independent minds —
beyond war and nationalism —
who live for different ideals."

there's only one way to smell a flower

but there's millions of ways to be free

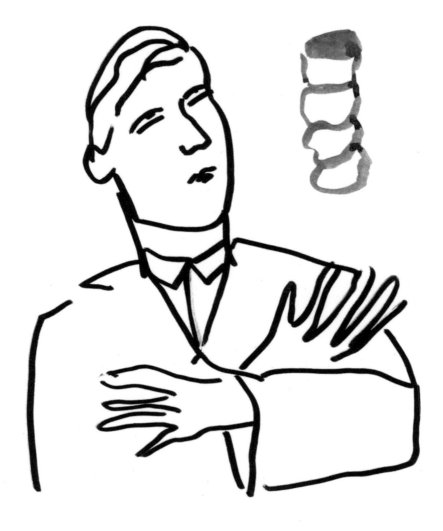

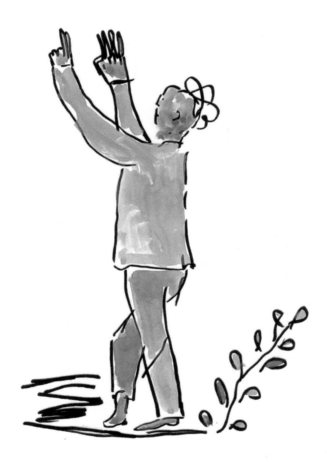

LiZARd LicK,
NC.

Two Egg, FL.

well we know

where we're going

but we don't know

where we've been

and the future is certain

give us time to

work it out

NOGALES, AZ.

imagine rolling down the window

imagine opening the door

must a question

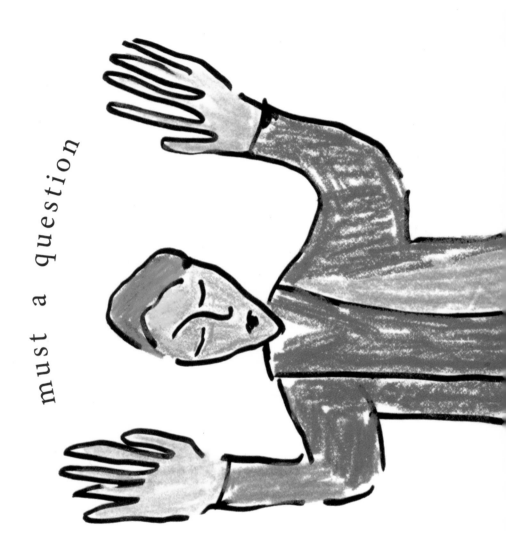

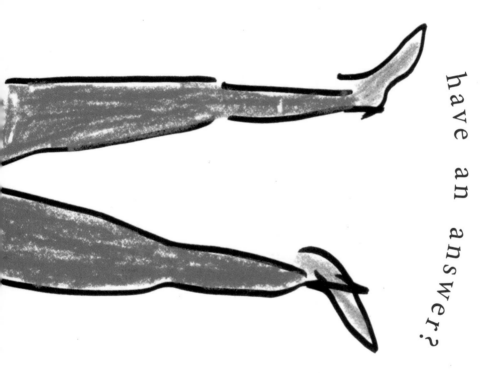

have an answer?

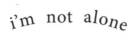

i'm not alone

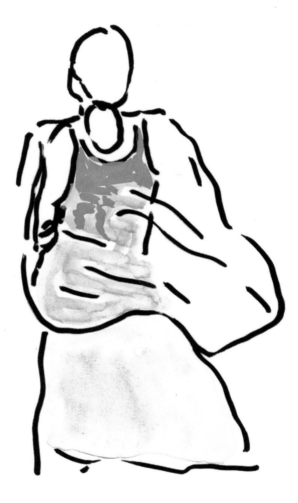

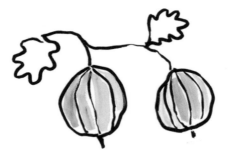

and we're all the same

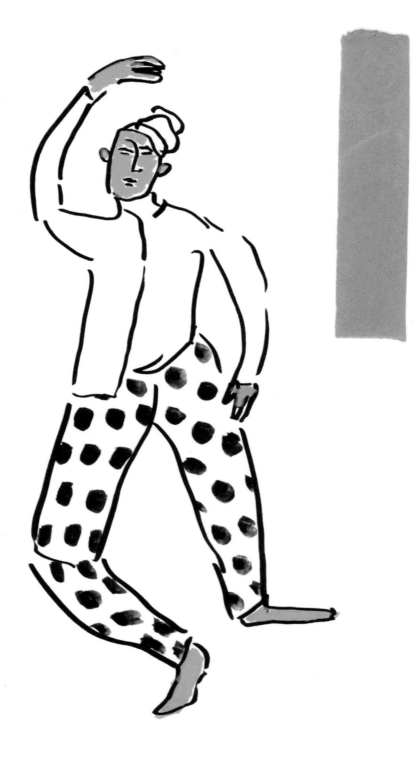

We dance like this

Because it feels so damned good

If we could dance better

Well, you know that we would

I'm working on my dancing

This is the best I can do

I'm tentatively shaking

You don't have to look

BULLFROG
UT

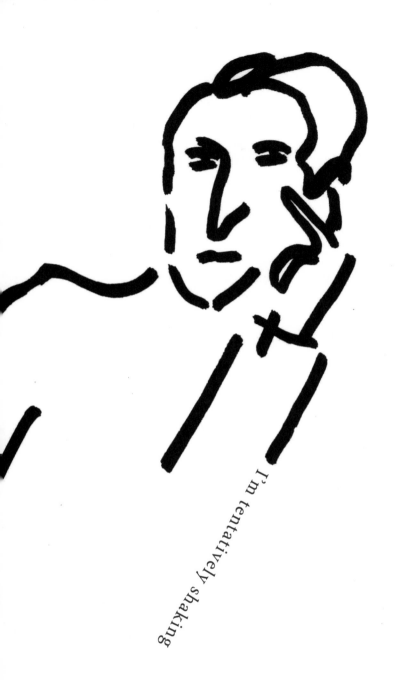

I'm tentatively shaking

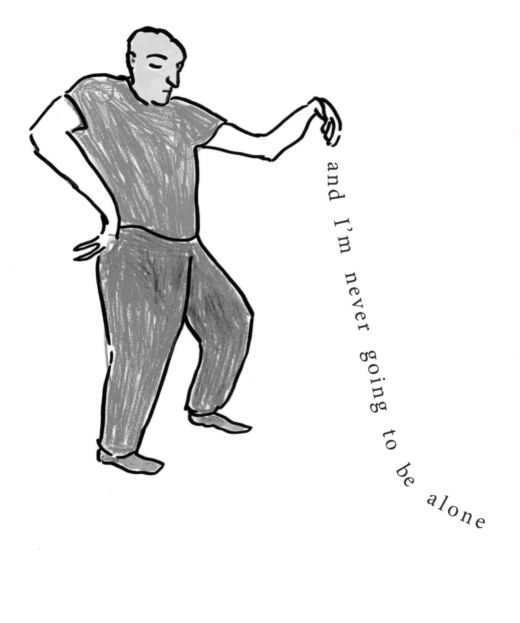

and I'm never going to be alone

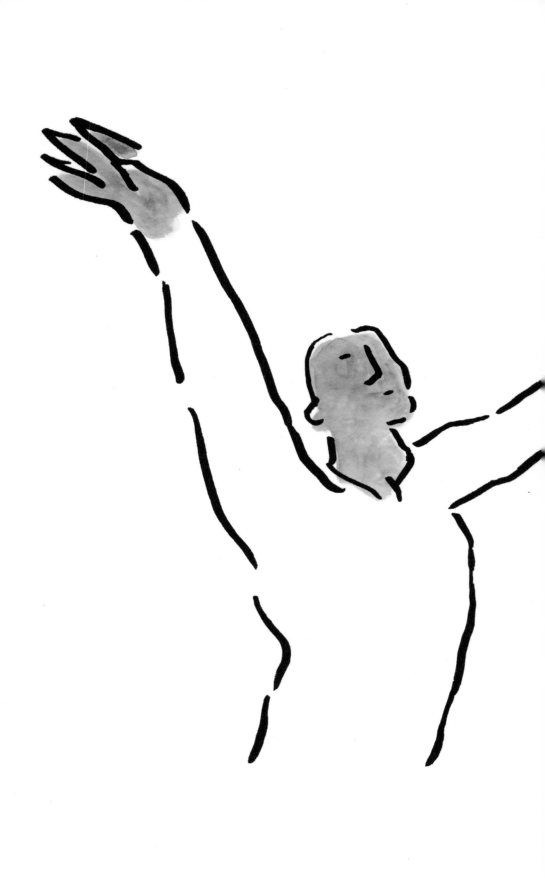

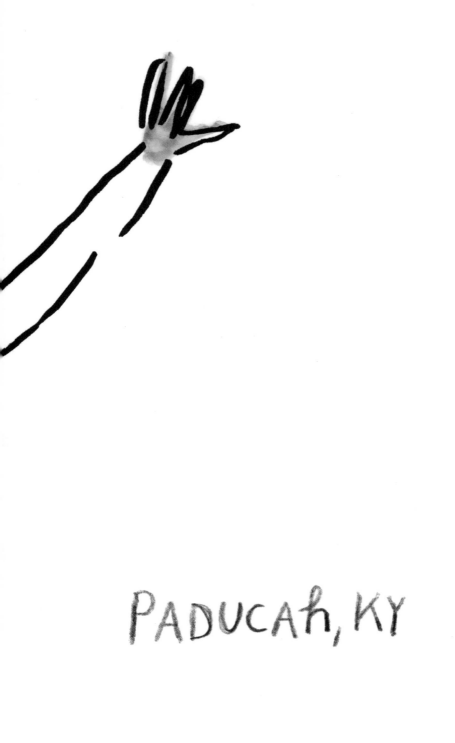

PADUCAH, KY

here is an area of great confusion

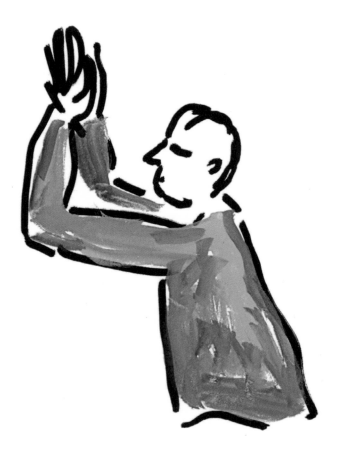

no more information now

LAZY Mountain, AK.

SHE
BOY
GAN,
WI.

this is my job

PORCUPINE, SD

SElma, Al.

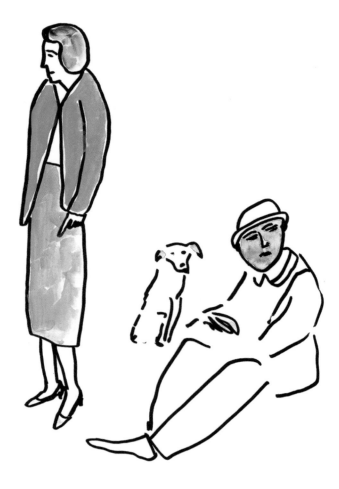

raise your eyes to the one who loves you

it is safe
right where you are

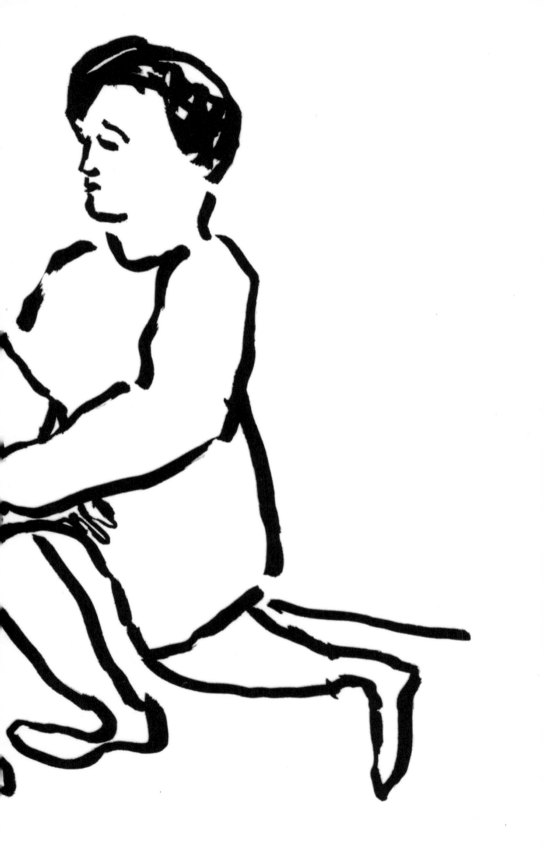

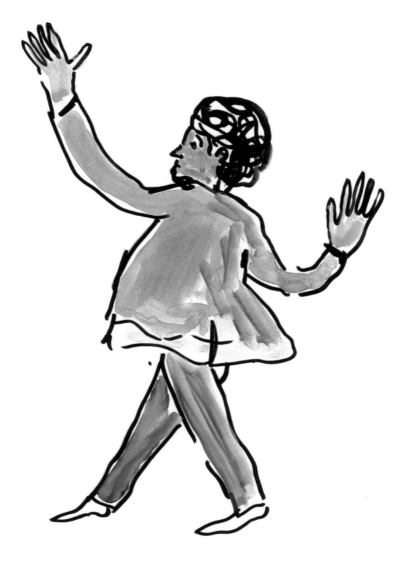

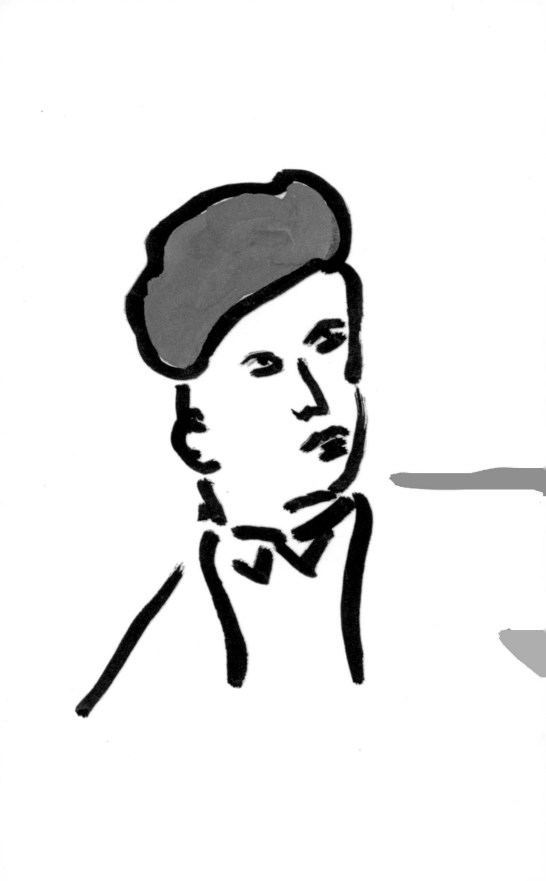

GOOFY RIDGE, Il.

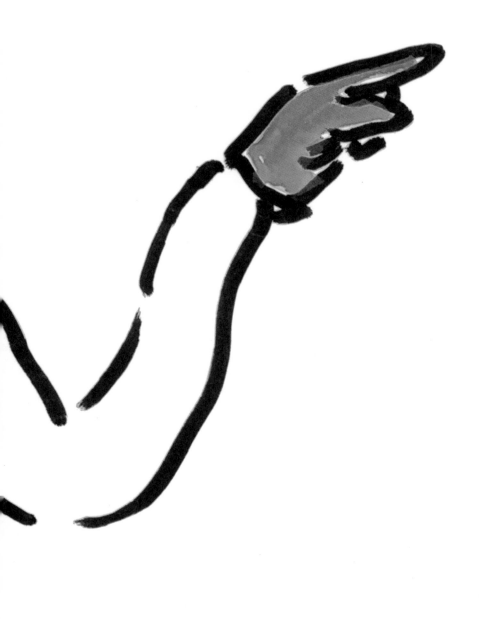

Thunderbolt, GA

FORKS

OF

SALMON,

CA.

we're only tourists in this life

only tourists but the view is nice

it's nothing special

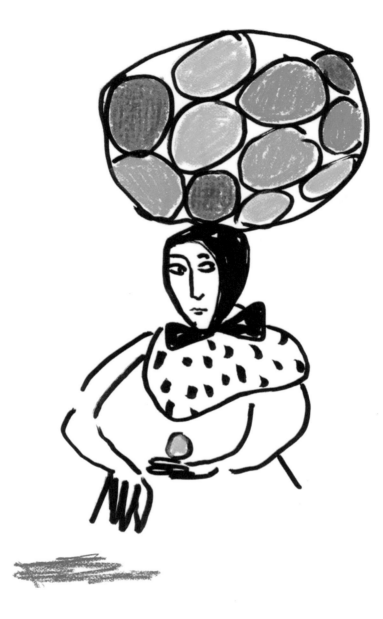

it's nothing profound

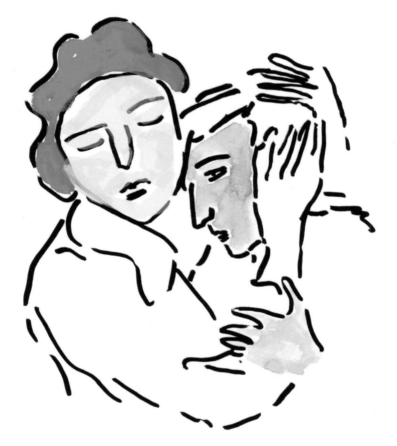

here's the connection with the opposite side

here

here

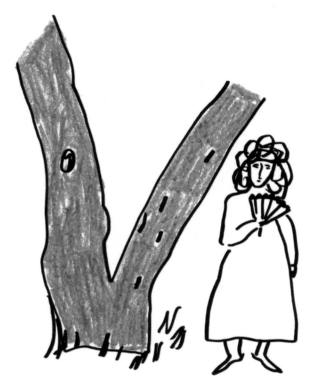

here

i'm not alone

and we're all the same

and the world won't end

it will just change its name

us and you

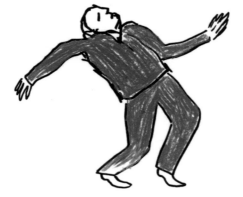

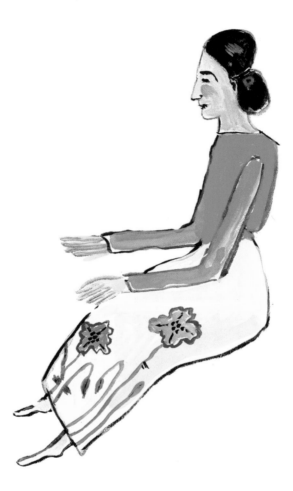

The words and art in this book come
from David Byrne's *American Utopia*.

David Byrne was born in Scotland in 1952 and is now an artist, writer, and musician who since 1974 has lived in New York City. He has a daughter and a grandson.

Maira Kalman was born in Tel Aviv in 1949 and is now an artist, writer, and designer who since 1954 has lived in New York City. She has a daughter, a son, and two grandchildren.

BLOOMSBURY PUBLISHING
Bloomsbury Publishing Inc.
1385 Broadway, New York, NY 10018, USA

BLOOMSBURY, BLOOMSBURY PUBLISHING,
and the Diana logo are trademarks of
Bloomsbury Publishing Plc

First published in the United States 2020

ISBN: HB: 978-1-63557-668-9; eBook: 978-1-63557-669-6
Barnes & Noble signed HC: 978-1-63557-687-0

Library of Congress Cataloging-in-Publication Data is available

2 4 6 8 10 9 7 5 3 1

Edit & Design by Alex Kalman / What Studio?
Printed and bound in the USA by Worzalla

To find out more about our authors and books visit www.bloomsbury.com
and sign up for our newsletters.

Thanks, Alex Timbers, for mentioning

that a drop curtain was a possibility...

and thanks, Maira, for turning that into a reality.

Here is the hope and joy that I believe emanates from this show

turned into something you can hold in your hand—

thank you, Maira and Alex Kalman

d.b.

Thank you

Charlotte Sheedy

Nancy Miller

Alex Kalman for making this book happen

and mostly mostly

David

m.k.

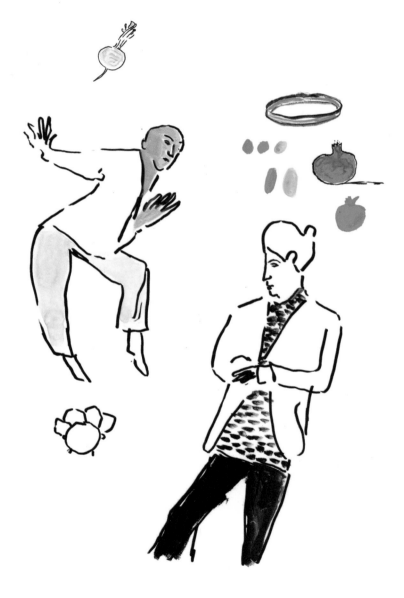

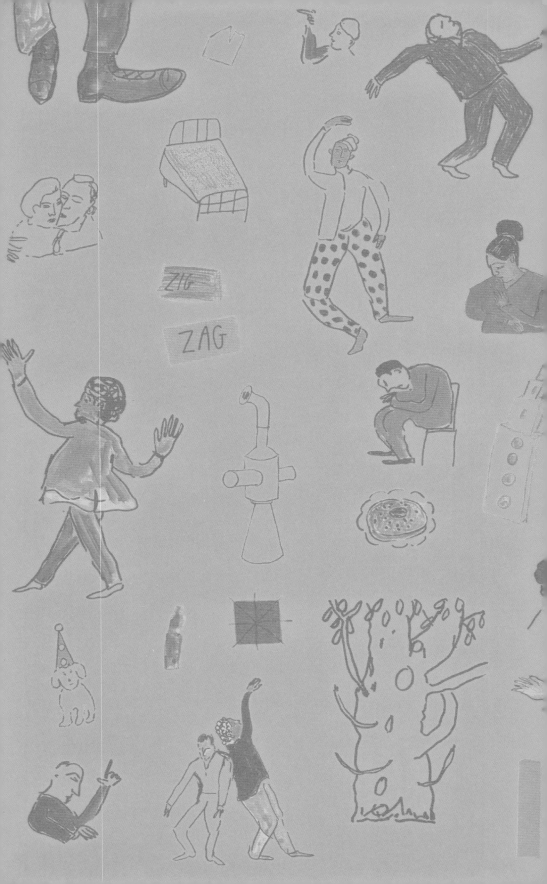

ZIG

ZAG